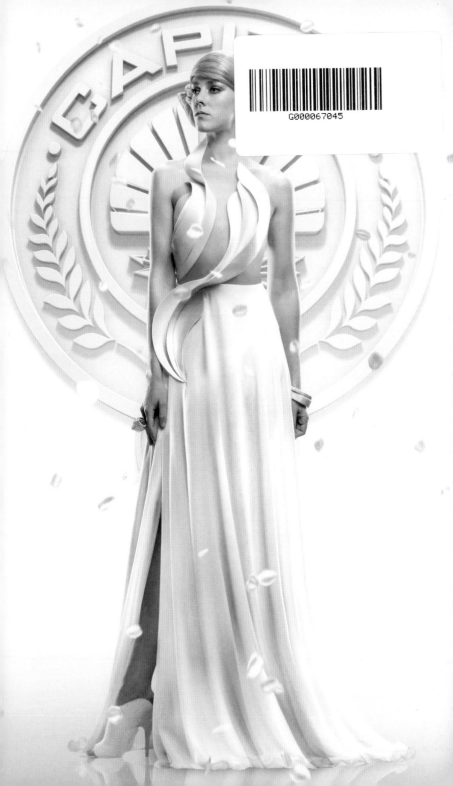

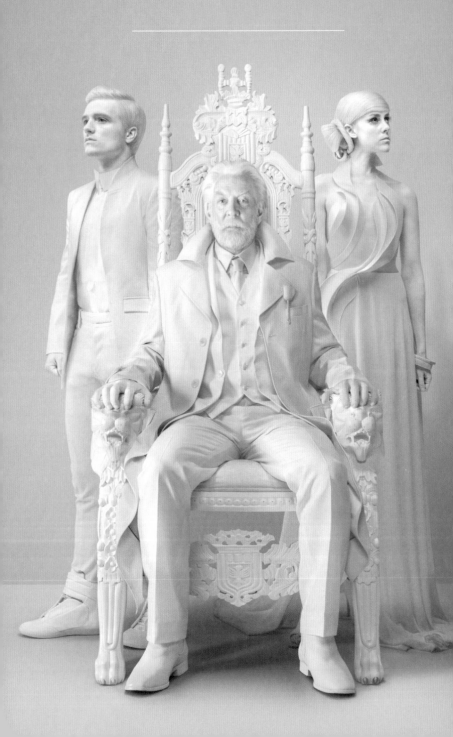

THE CAPITOL

THE WORLDWIDE PHENOMENON of *The Hunger Games* continues to set the world on fire with *The Hunger Games: Mockingjay - Part 1*, which finds Katniss Everdeen in District 13 after she literally shatters the games forever. Under the leadership of President Coin and the advice of her trusted friends, Katniss spreads her wings as she fights to save Peeta and a nation moved by her courage.

INSIGHTS

INSIGHT EDITIONS

San Rafael, California
www.insighteditions.com